Imaginationally

Michael's Lovable Fun of Dictionaries.

Written and illustrated by
Michael Bernard Loggins.

Manic D. Press
San Francisco.

Also by

Michael Bernard Loggins
" Fears of your Life"

 ISBN 978-1-945665-09-7

Book design by em dash

Dedication

I dedicated my Dictionary Book to Scott Ray Becker because he's a Groovy Kind of Human being to ever been Discover on this Face of Life on Earth. he is Good and Honest in Someways. I Admire his Ability and Quality in this Life as I Sort of Speak. He loves me very much, and Loves to Brag about what I does in my Life, But otherwise Everything Feels Just Right at the moment.

To Hope Goodall, I Love you so Dearly and so Deeply Til I Just Felt up to Dedicating my Love, and Dictionary to you as I Really approach you Face to Face with lots more Compliments than I would with lots of Lifesavers Crammed into my mouth-Piece til It's hard to understand what I Actually Babbling to you in hard Language that you decide to Give me a hard Laugh — Within Laughter Joy, happiness and Entertainment and Love all Combined together.

Abbreviations used in this Book.

adj. — adjective
adv. — adverb
n. — noun
V. — verb

Introduction

First of All I wanted to make me a dictionary because I Never made one before in my life and I thought I would make me one of my own.
Just For the Heck of it. And Enjoyment and thrill and pleasure. It's real Fun to make my own definitions for Every word that I represent to the world and public. I hope that it come out Great.

Hopefully People will like this dictionary and Love it as they did my "Fears of your Life" Book and benefit from it and Enjoy it around the Same amount and the Same way. something like that. My dictionary might have good words that you will want to use in your book some day in life. To be Frankly with You all, I Love what I do when it comes to making something whole, new and meaningful for the Greatness and Progress of the Book.

Michael Bernard Loggins. 2007.

Associalize, V. almost like associating with people that you meet in Life. Like a social Life kinda theme. Ex: It's hard for me to associalize with people when I'm feeling down.

associalize.

batouche, (b u h-tootch),

n. another word for butt like when you're angry at someone. Ex: "I'm gonna kick you in the batouche!"

batouche

begginned, V. to start making friends and making a New life and start going out to lunch together and hang out in the — Cafeteria and talk over lifestuff and start watching new T.v. Programs that you like ex: Love has begginned.

begginned.

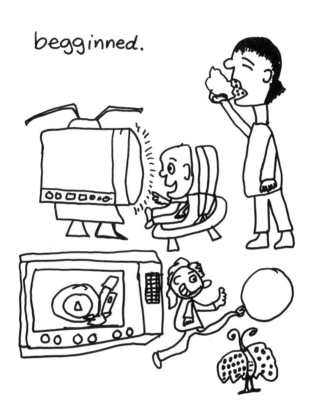

blank-trip, *n.* When you leave home to go to the place that you would normally go to and you come to the conclusion that it's closed. Then you say: "Oh, bummer! That's the way LiFE works out sometimes. that's LiFE." ex: I went to Jack's Record Cellar shop on Tuesday and I forgot that they doesn't open on that day. I said "Oh, Geez whiz" I said "I made a blank trip for nothing."

blank-trip

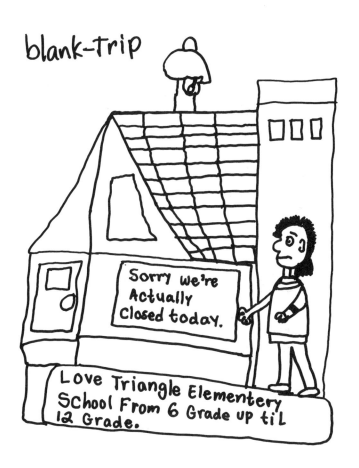

blue-out, n. almost similar to a black-out. Instead of seeing black you see blue in your presence. Everything seems blue to you. Ex: When you only decorate the Christmas tree with only blue ornaments all over the tree so the tree be full of blue-out in color blue til you're seeing blue dizziness.

blue-out.

Car-honkin-Season,

n. When a lot of people is in a hurry to get where they are going and they want other cars to move along so they can go about their business to go on with their Life. People are so impatient these days. Ex: In New York City they always having Car-honking-Season hustling bustling every which way.

Car-honkin-Season.

Choirnessly, adv. Like making a lot of noise, keeping me up all day and night and keeping me from sleeping like I want to and they bark all at the same time to make their "choir" as they go along. ex: Choirnessly when Dogs kept Constantly barking all times of night — or day. Keep me up complaining about it, and wondering when will they zip their lips. Because I cannot sleep with all that noise that actually continue On with Life.

Choirnessly.

Chronical, adj. when a problem is really bad. ex: when there is a problem, Man is there a real problem-Chronical!

Chronical.

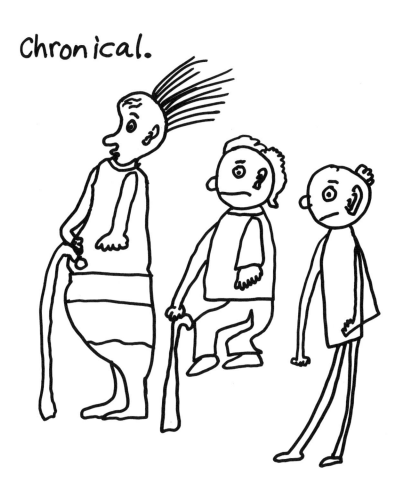

clownshipment, *n.* like a good relationship with other clowns. ex: clownshipment is a bonding relationship in a clown's friendship kind of world. GOOd LiFE! Two clowns laugh as they maintain with each other through thick and thin.

Clownshipment

Companionshipmate, n. like Friends and Family that you come in contact with. ex: When Friends socialize in a party of the Lifetime then they become good friends with each other, Okay....

Companionshipmate.

companionshipmate.

Considerating, V. Showing Kindness and thoughtfulness for Some one. It means sweet. or sweet person towards one another. ex: I brought Hope some markers and other supplies because I were or was being very nice and Considerating about it.

considerating.

Cool - behaved, adj. like well behaved; not making trouble. ex: I was being cool-behaved when I approach my friend at Community thrift store when I taken in a radio in order to trade it for another one, so I was cool-behaved so I can get my new radio.

Cool-behaved.

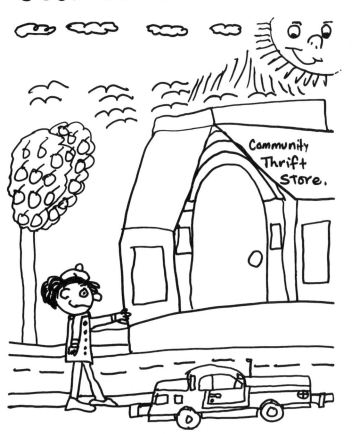

cooling-out, v. like when you're calming down from being mad and angry and Frustrated. And not kick anybody in their batouche. ex: I am cooling-out from FEELing very Frustration and being angry with the world.

cooling-out.

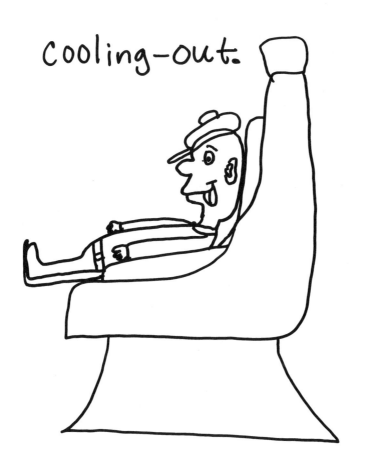

dangered, adj when you put yourself in Jeopardy. ex: Never Jump in Front of an automobile while it is what you Call moving in a Fast speed. You will get Killed or Run down - Same thing. I wont Jeopardize my Life with an Automobile so I wouldn't want to put myself in a dangered way.

Dangered.

dangerment, n. It has something to do with danger. ex: Rain may be wet and slippery as Ice on those brick sidewalks of brick and concrete ground of danger ment.

dangerment.

darksighted, adj. When you can't tell one object from another because they are both dark in color. This happens a lot during the rainy day season. ex: I couldn't tell what type of bird it was because the sky was so dark and the bird kind of blended in with the sky. I was darksighted.

Darksighted.

disencourage, v. When people don't talk you into doing wrong things, instead of encouraging you to follow in the wrong lead, like stealing food and beverages and clothes and candies. ex: Disencourage a boy to smoke pot, or crack. Don't let that go through his head.

disencourage.

disresponsible, adj. Similar to irresponsible, Can't be trusted and that Person won't be nice about it. ex: A disresponsible person will get in trouble if they Set the restaurant on fire.

disresponsible.

down talk, n. when you talk back to the person that you're mouthing off to. ex: I would feel awful if someone would holler at me, and I kind of down talk to them. I feel that I'm in part of the argument with that particular person that I'd down talk to. Sorry that I down talk to you but I don't like it when you get up in my face: we both should be sorry to each other Right now. And Promise not to down talk each other ever again. Be very kind and nice toward each other.

down talk.

dramaticalism, *n.* acting or being over dramatic like trying to hurt yourself and take your life. ex: You're showing dramaticalisms when You're upset, and we can Sit down and talk this over. And tell me Just how You're feeling. I Love You very much and I wouldn't want You to take Your life away from yourself. Don't show a

dramaticalisms, okay?!

dramaticalism.

Drink-out-Party, n. like when you get drunk or high and having a good time hitting on Every lady that You see and Flirting with them and treating them to beer and Laughing and having a good time of your life. And being a good sport and not Causing trouble or make things worse for Yourself to this Point. Ex: I like to go to a drink-out party to maintain with new people and Drink soda but not alcohol so I wouldn't over do it. I meet new People that I never seen before at the drink-out-Party.

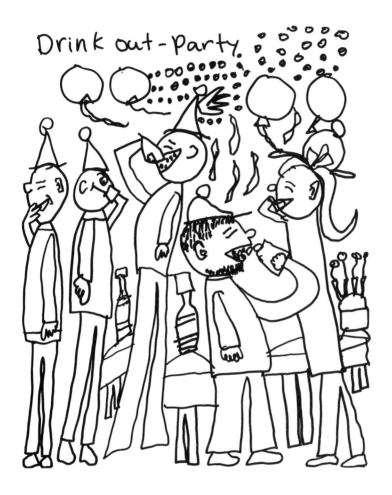

Foodful, adj. when something is like food. ex: a hot dog isn't as Good, but it's Foodful.

FoodFuL.

Foolishment, n. being kind of like being a jerk I guess. Kind of like a clown and clowning around in class doing weird things. ex: the boy clowned around in class showing his Foolishment in classroom once more.

Foolishment.

Foot Freeway; n. a sidewalk when you're in a hurry and you have to go somewhere and do things. ex: I went into the store to buy me something to eat. There were lots of people from the Foot Freeway into the store about to run me down.

Foot Freeway

Forcement, n. When someone makes you go somewhere or do something against your will. Ex: The landlord used forcement to make the people move out of the home because they weren't keeping up the lease.

Forcement.

Franatically, adv. A longer version of fanatically. When you get obsessed with it. ex: I was so franatically obsessed over French Fries that I couldn't resist them and couldn't leave those fries alone.

Franatically.

Freezer's chills, n.

When the wind blows out there by Ocean Beach it brings a real cold freezing air in and it kind of gets inside your body and you feel cold all over. It goes up your spine. Ex: When the season is wintertime I get cold, and the freezer's chills goes down my spine.

Freezer's chills.

Funable, adj. when you go to a park and play one on one basketball. It also means enjoying your life as you are living. ex: when I go over to my Girlfriend's house to hangout with her it's a funable way to enjoy LiFE.

Funable,

Growsack, n. for one thing: You can be born in it. It's something inside your mother's body that you can be born in. ex: I was born in a Grow sack when it was time for me to come out of the growsack to return to Life, in a big world of God's. My mom and Dad brought me home from the Hospital.

Grow Sack

hangcliff, n. like on a mountain, on an edge where there's a tree branch and you do hang from it and you'll be scared to death that you might fall from it and hurt yourself. ex: Don't get so close to the 'hangcliff' if you ever are at Ocean Beach of Greathighway. Otherwise you will go overboard into the water. which you wouldn't want that to happen. Stay away from the hangcliff. in order to stay as safe as you can possibly be. I want you alive, not your life be taking away from yourself. keep off the hangcliff area. Please! Okay?!

Hangcliff.

Hectical, adj. Very busy at work for 48 hours. ex: When katie is helping out with meals, like serving food, She gets very hectical once in a while and she don't have time to talk.

Hectical.

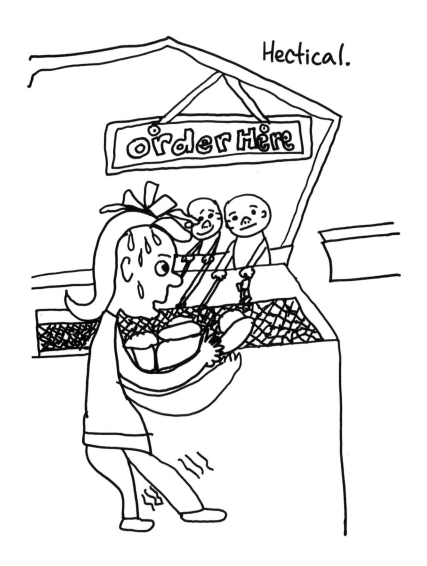

home marker, n. the kind of marker (pen) that belongs at home. ex: You can't bring it to school because it's called a home marker only.

Home Marker.

Horroriest, adj. Very Frightful.
ex: Halloween can be scary and
movies can be horroriest too.

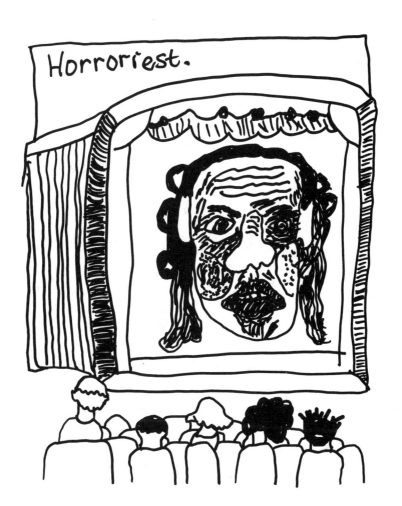

Human bank, n. when ordinary people see you walking down the street and they ask you can you give them some change or a few dollars to buy them something to eat or drink and they shake their cup of change at you like they expect you to give up your change to them. ex: you say to them: "I don't have any. I'm not a human bank, like Bank of America."

human Bank.

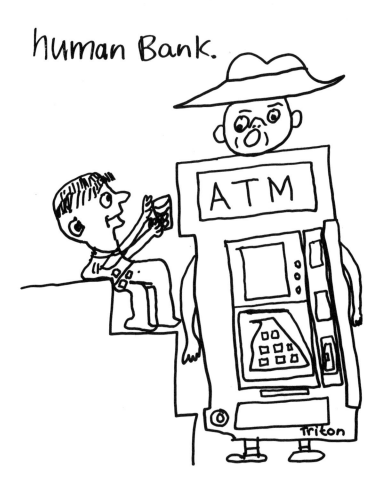

Humanful, adj. like us people.
When you are like real people in real life and
have a life in you to help you move
around. Ex: That was very Humanful of
Hope Giving me a Good Compliment on
my work.

Humanful

Illusionable, adj. It's an illusion to the world; It's something unreal. like a Dream when you sleep. It's not a real life; It's a Dream life. It's part of your Imagination. Ex: I had this Illusionable dream of me having lots and lots of records, more than what I actually have in reality in my bedroom. And I was so happy and surprised by them all.

ILLUSionable,

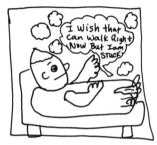

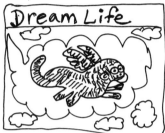

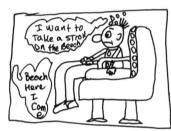

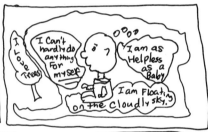

imaginationally, ad v. strong imagination. Powerful imagination. Smart Imagination. ex: You have Imaginationally good art in the kind of work that you do.

Imaginationally.

irritational, adj. when something is bothering you or troubling you and worrying you like crazy. Ex: I find it irritational when I'm having trouble trying to find someone to help me with my dictionary.

Irritational.

Knowledgement, n. like kind of smart in a good way. And you know everything that you could possibly know. And you know what's going on around you in your environment and you feel safe not looking behind you every five seconds that you walk down the street. Ex: I have that knowledgement to know what's going on in my environment around me to be safe and feel that I don't have to look behind me every five seconds when I walk down the street.

Knowledgement.

Laughterful, adj. when you see something funny on television, like a real funny cartoon it will make you laugh your head off. Laughterful is something funny. ex: It's Laughterful when you see milk come out of a boy's nose.

Laughterful.

Life-stuff, n. It's what we do

Everyday as our daily routine. Almost like Social life kind of stuff. Ex: Everyday I wake up to the morning to feel fresh and ready for a new day in order to start doing life-stuff.

life-stuff.

Life - surprise, n. like when like all my friends unexpectedly come meet me at a place I go to and they hug me and give me a kiss a little bit on the cheek and they tell me they do their life stuff Everyday. Ex: Life-surprise is Fun.

Life surprise.

Gather around the table

Eating on this Big Cake

Liferrifically, adv. when people do stuff that helps them enjoy life. If you do things that way it will bring good into the world ex: They will have a

Liferrifically good time on the picnic

and have a nice day.

Liferrifically.

Life teaser, n. like a bully that comes

to a school cafeteria and makes trouble for a Girl and a boy and pushes them around and hurts their Feelings and puts them down for what they really are and talks about their mothers and provokes a Fight but he gets his tail whooped by the Girl and the boy that he was picking on. He learns a valuable lesson: never tease again as long as he lives. Ex: This boy became a life teaser when he goes around the school bullying all school children. He makes trouble for them and takes their money that they use for their Lunch.

LIFE TEASER.

Los Angeles dog, n. a dog that travels with his master wherever he goes if it has to do with Los Angeles. Ex: my friend has a dog that was born in Los Angeles. He is born 9 months old. He stays with his master that loves him very much. He does movie films in Hollywood as a Hollywood star. He's a Los Angeles dog.

Los Angeles Dog.

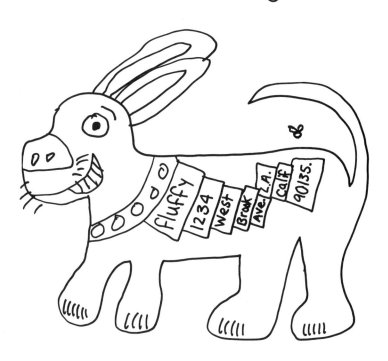

mischoose, V. taking something by mistake. ex: I hope he doesn't mischoose one book over the other one.

Mischoose.

phasefully, adv. like a

frightening experience that you go through as a Child on a stage at school, like a Christmas Pageant. or like when you go through your parents passing away — It's totally hard; it totally makes life hard for us. Ex: I went through life Phasefully like when I went to the Hospital where my mother was and she had died and I cried across her chest. Life was hard for me and I experience life totally.

Phasefully.

Girl up on the stage.

Doing one of her play.

Frightening experience

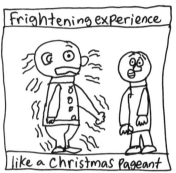

like a Christmas Pageant

Rest in Peace Quietly nice Funeral Home

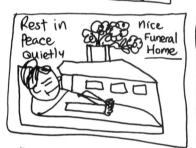

Mother Had Died 7 minutes ago.

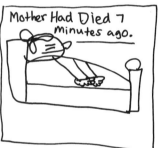

LIFE is totally Hard

on us ALL Sadly.

Life is like Heaven in sky Right Now Heaven.

Time For Heaven.
Going up in Heaven Right now.

Plastical, adj. That is not real; It's made out of plastic. like artificial flowers. It's not made like the real ones that matter. Ex: something that is plastical happens to not ever be as real as life.

Plastical

Real

Fake

Scummeral, n. like a scoundrel who is a scum-bucket too. Ex: I am very sorry that that word sounds so hurtful and you wouldn't want to be that word scummeral but to be honest you are a low life scum bucket because you cheat on my friend's money that you promise to pay him what you owe him.

scummeral

The Halloweenie
Monsterzilla.
Do not Tangle up in a
Dark Dark ALLey.

Snubbled, adj. Like you have
to sneeze and you have the sniffles. And
if you have a worse cold. And be out in the
Freezing weather. EX: I felt snubbled
waiting for a bus in a Freezing cold
wind yesterday.

snubbled

Soulistical, adj. like musical Jazz, soul and like a tune. like James Brown plays his music. Ex: when I goes to Jack's Record Cellar I like to look for records that are soulistical.

Soulistical.

STainful, adj. causes
stains. ex: Paint can be stainful
if it gets on your pants.

STainful.

Taughted, v. Like teaching a child the Abc's. ex: I taughted myself how to play the record player.

taughted.

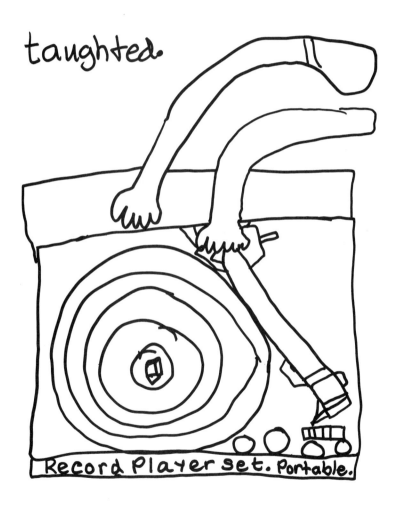

Record Player set. Portable.

Terrifical, adj. something that excites you and is like the Spanish word for beautiful (bonita). ex: people that we love (like Michael for example) are so terrifical in a special way that we don't want them to leave out of the world.

Terrifical.

Troublemakerhood, n.

It's a neighborhood where troublemakers hang out. For Ex: I warned a friend that there's

some dangerous parts in

San Francisco to be aware of,

not to tangle up in a

trouble maker hood.

Troublemakerhood.

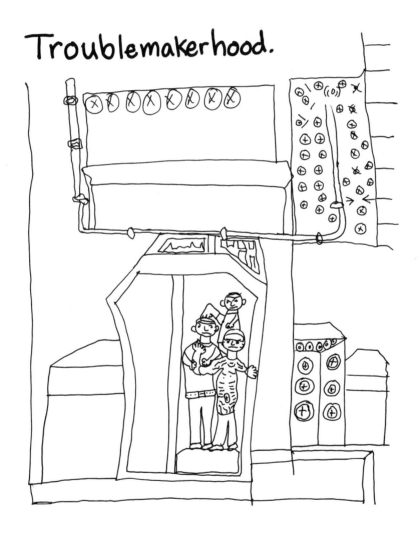

Troublemendolously, (truh-bol-men-doe-luss-lee), adv. It means like for one thing: like that Girl on Full House who says "You're in trouble mister!" and being funny. You will get in deep trouble. If You've done something wrong or bad. you're going to get in trouble. ex: You are in Hot water because You troublemendolously hit my Girlfriend in the mouth.

Troublemendolously.

Unclude, v. keeping things that you don't appreciate out of your life. Ex: I drinked milk once in my life and it made me real sick. So for now on I will remember to unclude milk from my diet like forever.

unclude.

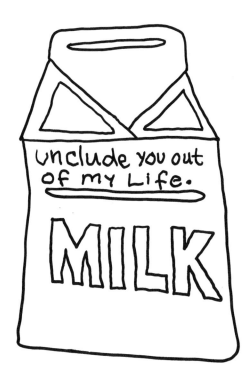

Unconsiderable, adj.
not very kind. ex: Diane
and Pauline are unconsiderable
Persons because they say mean
things to Hope and got
her in trouble.

unconsiderable.

Water Log, n. a

Log that you cross to get on the other side of the river. ex: Frogs sometimes hop on a water log to go wherever they are going.

Water Log.

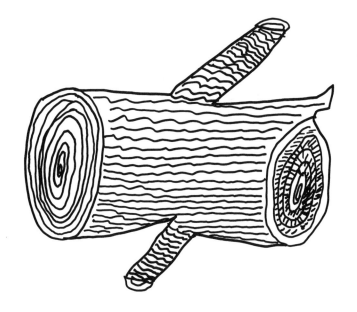

Worser, adj. is similar to trouble. ex: Jack hit Luke in the mouth. When Jack got caught hittin' Luke in the mouth he got in worser trouble than ever before.

Worser.

Worses, adj. The most horrifying experience. ex: what is the worses thing that can happen in the world.

worses.

You-ness, adj. maybe unique and smart and talented and original and regular. Ex: You-ness is what makes you special and unique in your work and makes you talented.

you-ness.

zincky, adj. When something is spoiled and nasty to eat and will make you sick. ex: that rotten orange is zincky.

Zincky

About the Author

I was born on Thursday, March 30th, 1961 in San Francisco, Calif. I have good experiences working at Creativity Explored doing good art and making money. I've been showing my work around the world and in different types of cities and states.

I collected 50 or 500 or 600 songs on my tape recorder. I have like maybe 2000 or 3000 45 rpm records.

My book "Fears of Your Life" has been heard through other magazines and the radio. Some of my fears from my book are on the CD called "This American Life: Stories of Hope and Fear." Kim Epifano (she's a choreographer and a friend) brought "Fears of Your Life" to real life performances. She decided to redo my book as a play so we all could come and see it and enjoy it. I saw it like three times. I love the title I made up for the movie called "Life is Real." It's about how me and my friend, Scott Ray Becker (he's a filmaker and a friend), started becoming friends and so on. I'm not sure when the movie is coming out. Scott will decide that. Arron Novik (he's a musician and a friend that I know from Adobe book store) asked me to bring some writings from home so he could

cont. →

Start his music using my own words from a long time ago.

I like to have fun, go places around san Francisco and hang — out with my girlfriend Hope a lot more. I hang out with Francis and scott sometimes. And maybe try to enjoy life as much as I can. I like to go on bus rides. I like to go hang out at Adobe book store, Dog Eared book store and Asqew Grill and Community thrift store and Burger Joint and Natural Health Food store. Sometimes I go to some burrito shops and Happy Donuts and Blue Front Café. And I hang out with Elizabeth and Pearl at Ocean Beach. I go to Safeway and Burger King and, uh, let's see sometimes I go to that store on Guerrero and 18th called Grocery and Save (or something like that) scott once took me to the place called Big mouth and we had lunch and life things together.

I find audio equipments on the street and take them home and try them out. they play like a champ! I entertain my girlfriend when we go out to lunch. sometimes I stay home and keep myself busy doing things that I like to do.

michael Bernard Loggins June 22, 2007. 3:37 P.m. and 31 Seconds to Exact.

Thank you

1. Thank you Jennifer For coming here to creativity Explored to check on the Book to see It almost being worked on as I am busy with My own Dictionary.

2. Thank you Alison For saying How you really appreciate My Dictionary Book, and that I done a good Job on it. and Giving me good Compliements and Encourage me to work on it wednesday May 9th 2007.

3. Thank you Nicole For Loving my Dictionary Book and my Vase as well. I'm So Happy that you Dedicated my Dictionary with compliements and Caring and Consideration as well.
 by Michael Bernard Loggins - inspirations on the way that I Carry my words around in Good Sense- And Life of me doing just what I Bring myself knowledge to work in a Style and Image. on Tuesday May 8th 2007.

4. Thank you Francis also, For starting me on making The Dictionary and The Decision making of what to Draw and write and What Definitions that I Should Put into umy Dictionary. Liferiffically was a good one.

CREATIVITY EXPLORED
A PLACE WHERE ART CHANGES LIVES

Creativity Explored is a visual arts center in
San Francisco where artists with
developmental disabilities have been creating
and Selling art for over twenty years.
to learn more about us, Visit
www. creativity Explored. org.

Life will be at creativity Explored no matter
what the circumstances will be.
Whether it's good-bad-or worse than what it
Seems or even those things Kind of get wacky,
or Slightly out of hand, soon or Later, These
things blows over and return to what
they will be.

— Michael Bernard Loggins.